YOUNG MASTERS AND MISSES

D1355581

Telfer Stokes

The Museum of Modern Art
1984

Thanks to Helen for the negs. Other books by Telfer Stokes published by Weproductions and Flat Iron Press

This publication of The Museum of Modern Art Projects Program has been made possible through grants from Agnes Gund Saalfield, the International Council of The Museum of Modern Art, and the Visual Arts Services Program of the New York State Council on the Arts

Library of Congress Catalog Card Number 84-61206
ISBN 0-87070-674-8

The Museum of Modern Art
11 West 53 Street
New York, New York 10019

Printed by Olsen Press, Inc., Cranford, New Jersey
Bound by Sendor Bindery, New York, New York
Printed in the United States of America

EL

LE

PLUM

OM

MHE

PIC

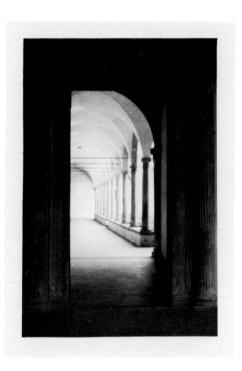

ICK

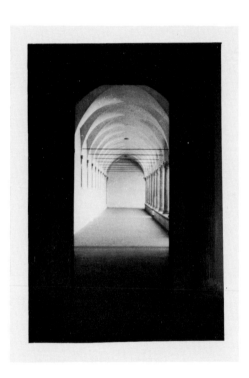

ICCT

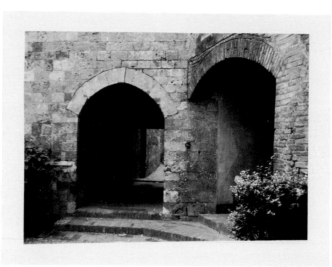

PACTS

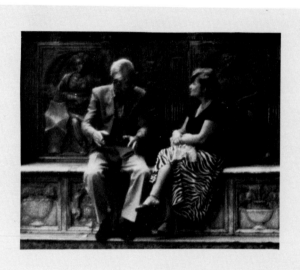

PARKS

PARTS

Callard raised his head from the pillow, he did not bring his arm up to rest his head like a prop Soon, he would drop the weight back on the pillow. Browsie lay on the other side of the bed facing the window

It was like sorting through a large pile of rubbish every thing abandoned because the burden of accumulation was so great.

On the other side there could be the same person free and with a keen eye picking things out.

We are at the kitchen sink stage of space travel. The astronaut in his suit can suck, chew, urinate and de- faecate while contemplating the view of Earth cacooned in its atmopshere the only planet in the solar system that can sustain life.

The agency that received the first photographs of Earth from space decided not to publish because most of the surface of Earth was in shaddow and they considered this to be disturbing.

Decided not to accept the other side that makes up the whole.

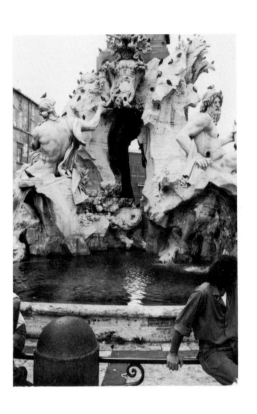

Callard could see them shuffling through the photos and selecting the most optimistic ones, full face to the sun 'Good publicity for the present administration.'

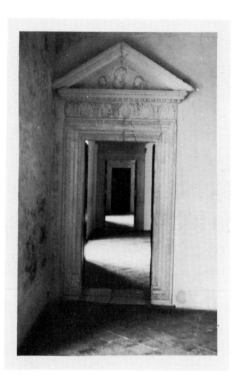

Anything will do for a lever but certain tools are better than others.

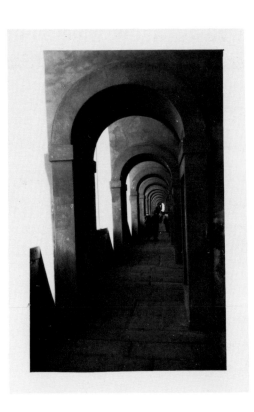

There was at one time an implement for scraping out jam jars on the market.

This implement which consisted of a piece of rubber on a stick was so successful at getting out the last morsel of jam from the jar that the jam manufa͜turers got together and offered the scraper manufacturer enough money to sell them his business.

They considered him a threat to their sales.

c/

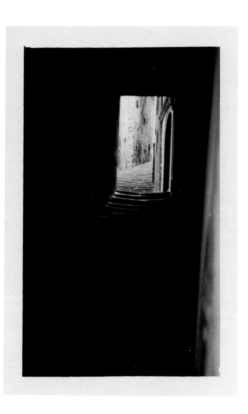

Normally, early on Sunday the streets were empty, none of the usual shops had opened and he had to go further than usual to get provisions. He came to a litter bin attached to a lamp post. Placed under the bin as if inviting the first person to slip them on, were a pair of good quality shoes, worn but well looked after, as rubbed and polished on the inside of the shoe as you would expect the outside to be.

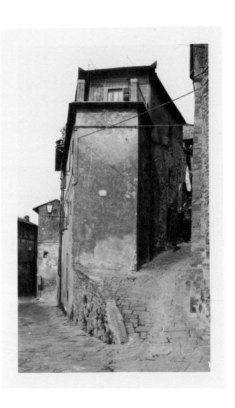

The corner shop was always a good excuse for leaving the house at least once a day. There were two views of the shopkeeper behind the counter, the tailored view and the untailored view when she left the counter and came round into the body of the shop. Every visit to the shop left him with a compoundation of views and he would return again and again to untangle and staighten the two views out r/

After a while he found that as a regular customer he could help himself to the goods in the front of the shop, in that way the shopkeeper remained behind the counter and he got the tailored view of her only.

Having always been scrupulously honest in his dealings, he realised one day that he should not have deprived the shopkeeper of the untailored display. She had charged him for goods that he had not bought

Callard lay on his stomach with his right arm bent under his body. He brought his arm up and slid it under his head. His head was then the top layer his hand under his head the middle and the pillow the third.

Pillow to head was like two rackets hitting a ball over a net, soft to hard alternately

He was standing on a slope among trees in the snow. He was struck by the way when branches were cut into managable sizes there was always a trunk end and a branch end, on and on to the last twig.

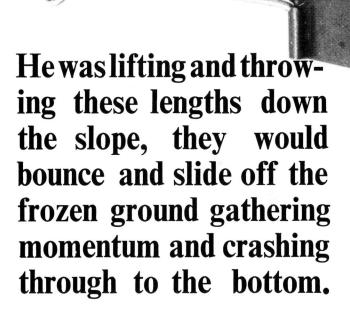

He was lifting and throwing these lengths down the slope, they would bounce and slide off the frozen ground gathering momentum and crashing through to the bottom.

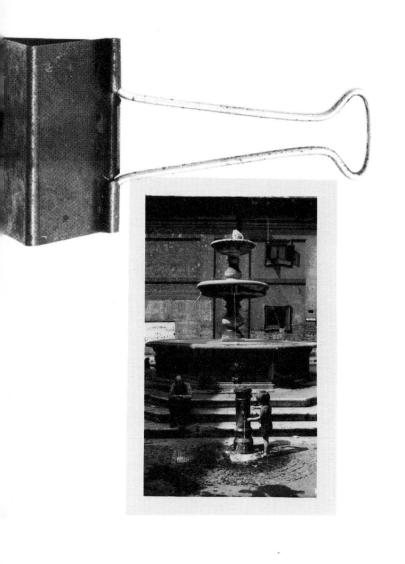

Every person is a link in the chain to someone else, he was examining each piece that he picked up, some sprouted two legs, some three.

There was a time when butcher's
blocks were quite numerous on
the streets, for instance there
were three to choose from down
an alley way near the site of the
Globe in Southalk. When there
were that many they seemed too
numerous to warrant a special
journey. You waited for one to
turn up locally. Of course that
never happened.

Everyone wanted a butcher's block, they were so useful, but most important they became fashionable. Furniture started to be marketed on the butcher's block principle. The new look in table tops, working tops veneered in teak all easy-clean surfaces.

Finally there was the model based on a block that had been used by three generations of butchers. This was 'the completely authentic looking butchers̆ block', in vacuum formed wood grained formica.

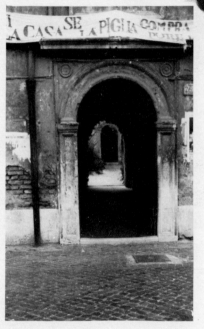

There was in the neighbourhood a lady that lived with two corgi dogs. Out walking, the dogs on twin leads seemed to have a will of their own dragging the woman along after them protesting and bad tempered. On one occasion she stuck fast in a hedge, the more the dogs strained and panted on the leads the louder she shouted oaths and obsenities c/
until the hedge gave way.

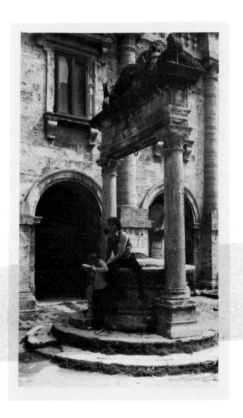

In the worst weather they would be out. If there was an accident or a barn caught fire or a horse trampled on a rider, lovers naked in the wood, they would be there, crashing out of the undergrowth, dogs going one way she tripped and spinning, going the other. When the old bridge went in the flood, one hundred years to the day that it was built, she was there.

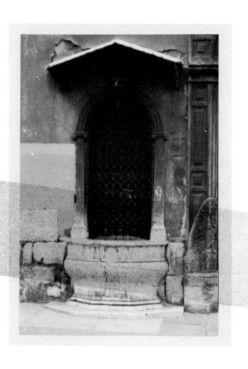

When the new bridge was finally built and the river flooded again, she was seen paused and waiting in the dark.

Browsie put the pot down on some newspaper. An advertisement for travel bags read 'hang it all, dont unpack it, just hang it in the wardrobe'

On the early morning radio programme 'Thought for the day' the Rev Yellowleas address was on the subject of 'Letting go'.

Let it all go.

She was clearing things up at Westminster Avenue, the white walls made it feel empty and cold and she was tired of packing things up and moving furniture. One of the rooms was occupied by a tea party. There were four or five people sitting on low stools sipping out of cups. They seemed at ease, cultivated and poised. One old man, dressed in doublet and hose, got up and hobbled over to the fire-place. As he was bending down to poke the fire he let off a big fart. Each of the others fell back insensible as the gas reached them in turn.

ONE OF THE ROOMS

A LINESMAN CAN'T KEEP RUNNING

Between her and the beach there was a golf course landscaped into the sand dunes, in the rough grass someone was stacking odd bits of timber, packing cases, drift wood, to make a fire. She wondered whether anything could be salvaged to burn herself. was a beacon the man explain they were lighting them all a the coastline when it was 'get rid of some old rope'.

'ike and

itself to

In some

From the cliff top every stone she looked at seemed remarkable, they all had distinct individual-ities. There was something flesh lik ng about s lent

 listic the hair would be stylised and also nex-pected things like blood dripping from he Trevi fountain in R e must have been built to celebrate the feat of squeezing water from stone.

On the headland she could see all the creations, the frothy waves, the snarling curls and the silken lank glimmerings. She looked down at the worn down landfall, the water lapped back combing every pebble and as it came up again, every rock parted its wave.

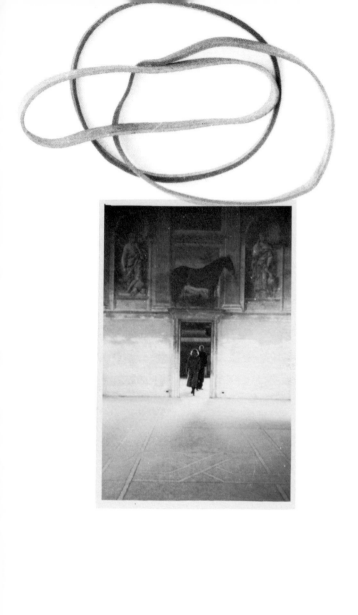

All the cases in the women's gynaecological ward were one disorder or another of the womb. There were mothers with post-natal complications and other women having parts of their insides removed. Despite the severity of these operations it was a cheerful place, it was as if when so much had been taken away there was nothing further to loose, so the best was made of what was left everyone talked incessantly, no one wanted to return home. When the day came, the husband would arrive to collect his wife, she would pick up her things and leave. Five minutes later, sometimes half an hour, an hour later the husband would reappear to collect her handbag.

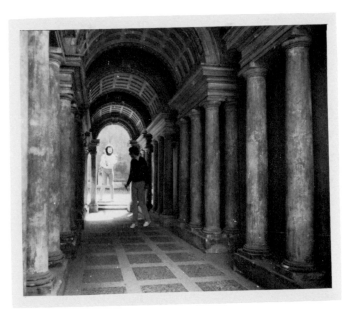

Her landlady took the old age pensioners bus which was free, into town to play Bingo on Wednesdays. On this occasion she was wearing a bright red suede jacket she had bought the day before. Looking up the road she was surprised to see the regular bus approaching and as she didn't want to pay the fare she decided to hide and she lay down in the ditch next to the bus stop expecting it to go by. The view of an elderly lady in a red jacket lying face down in a ditch will stop any bus in its tracks. She was forced to admit while the driver and passengers carried her onto the bus that she had had one of her bad turns and that it had been lucky they had spotted her.

tr down /

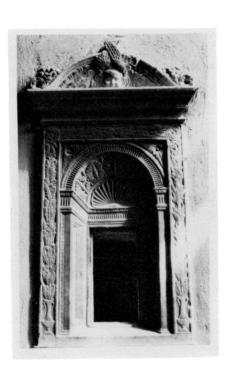